Johanna Basford

Small Victories

A Coloring Book of
Little Wins and
Miniature Masterpieces

life

PENGUIN BOOKS
An imprint of Penguin Random House LLC
penguinrandomhouse.com

A Penguin Life Book

ISBN 9780143137856

Printed in China

3 5 7 9 10 8 6 4 2

Interior designed by Johanna Basford
and Sabrina Bowers

Introduction

Welcome to the world of *Small Victories*, a place where good things really do come in small packages!

Over the last ten years of making coloring books, my life has changed a lot. I seem to be busier, with less time for self-care, but more in need of it than ever. And so the idea for *Small Victories* came about. This pocket-sized book contains little illustrations or single compositions that can be colored in one sitting. Whether you have ten minutes or half an hour, this book invites you to pick up your colored pencils and complete a miniature masterpiece.

So, my friends, flip through the pages, find an inky drawing that charms you, and have fun!

Much love,

Johanna x

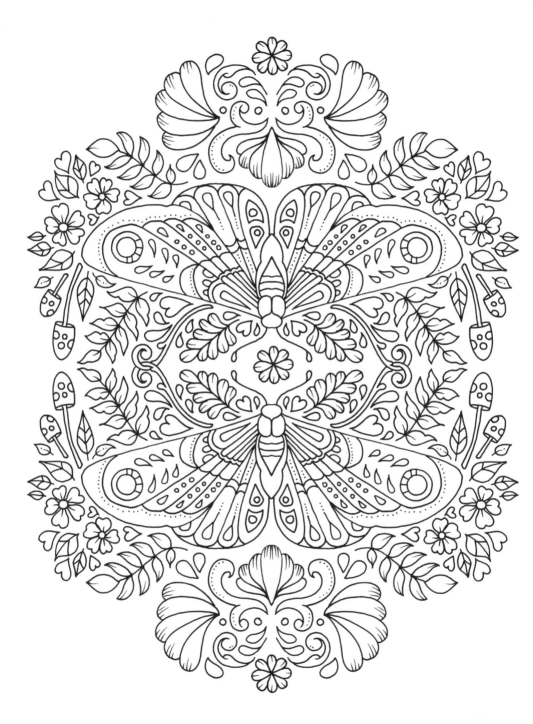

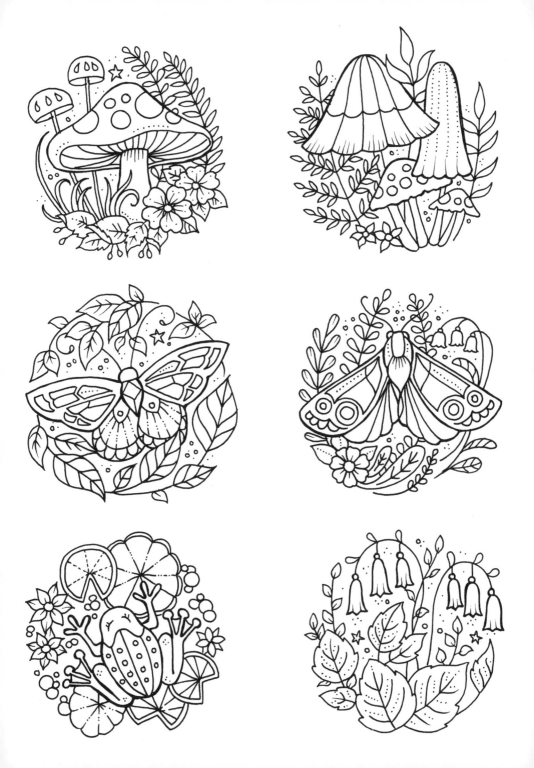

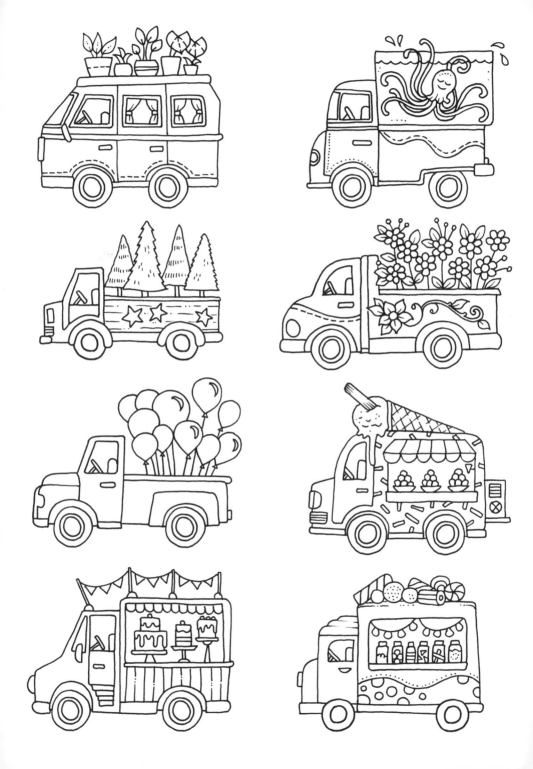

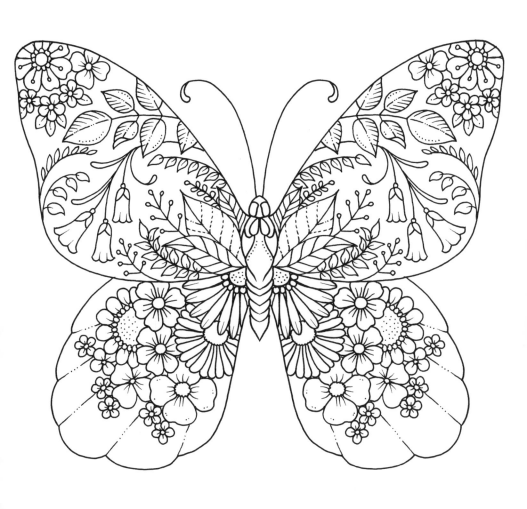

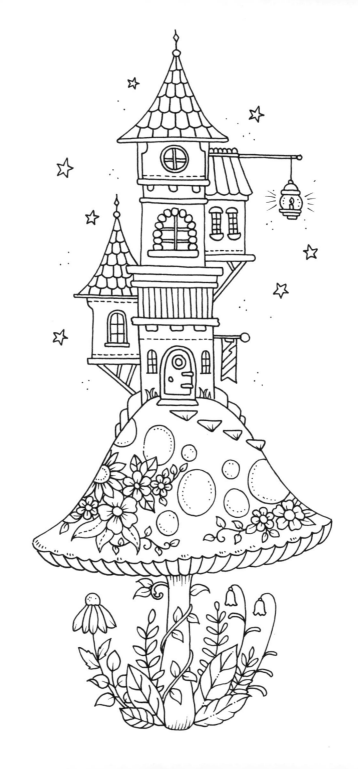

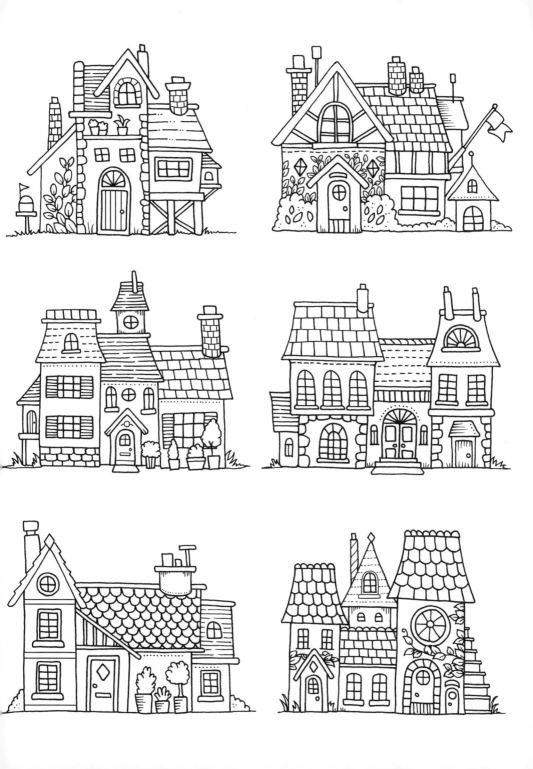

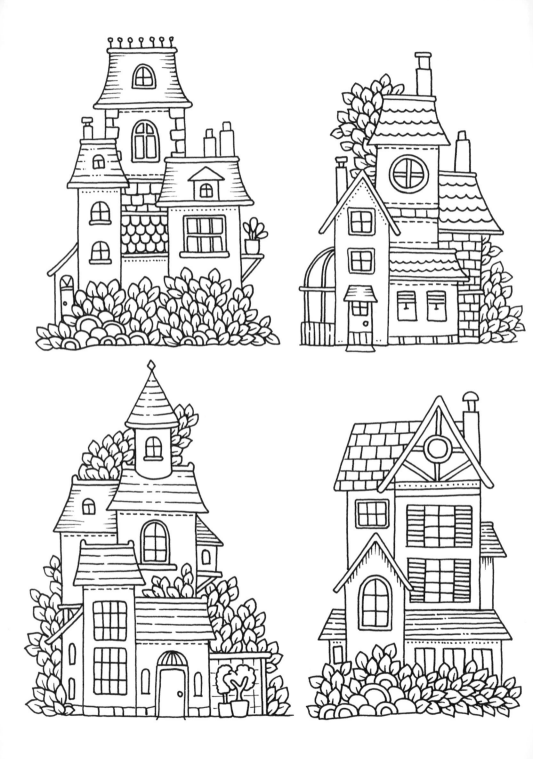

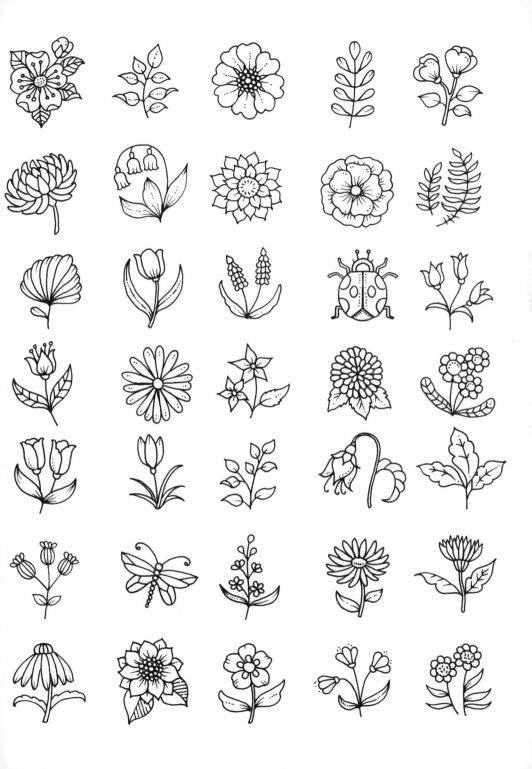

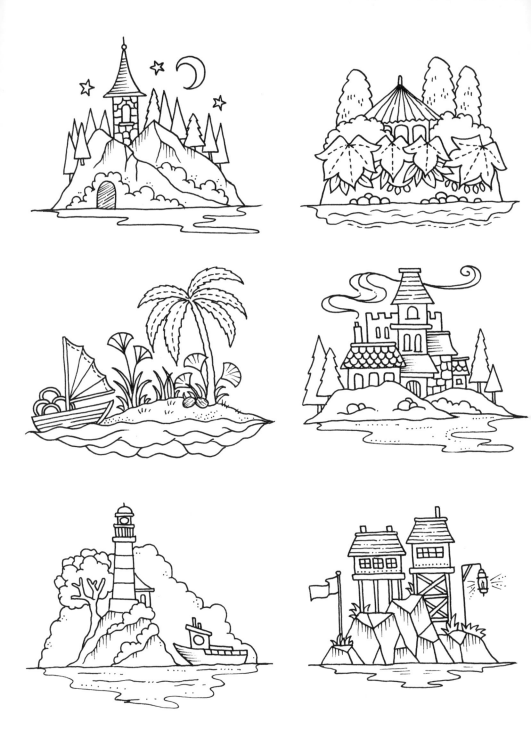

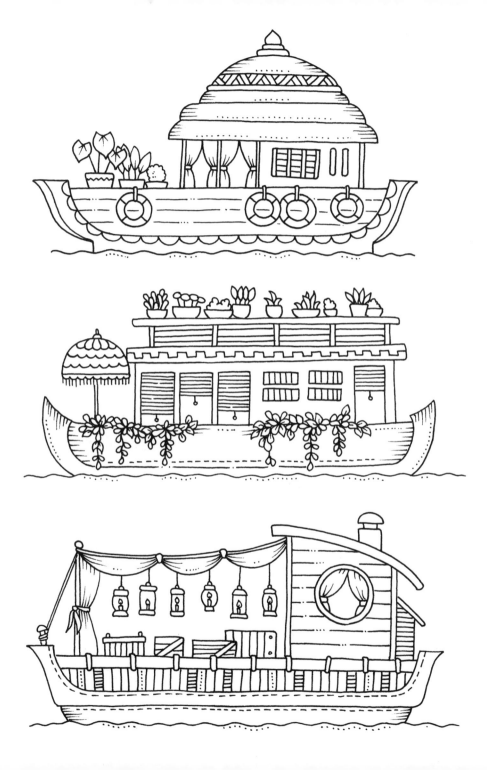

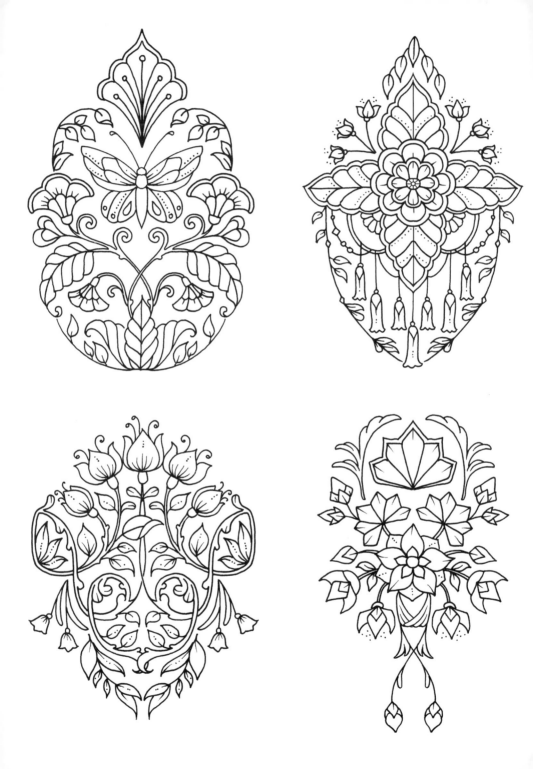

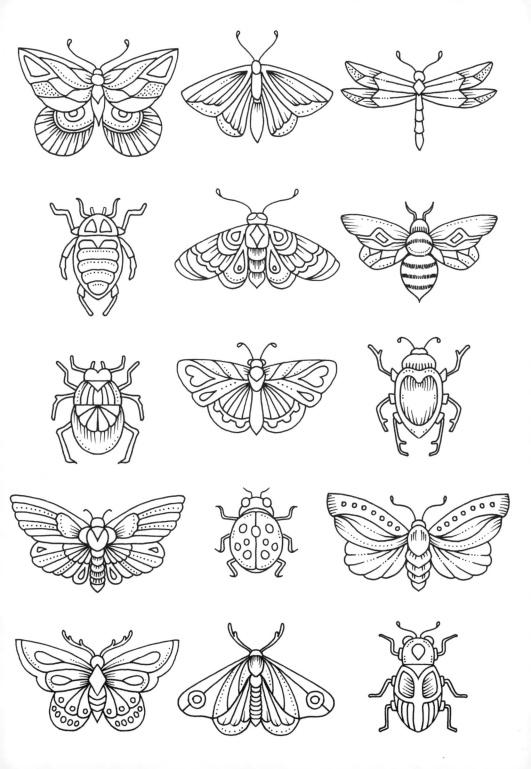

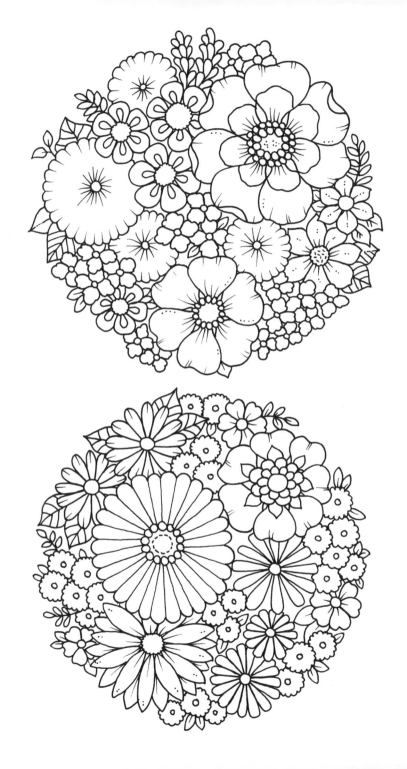

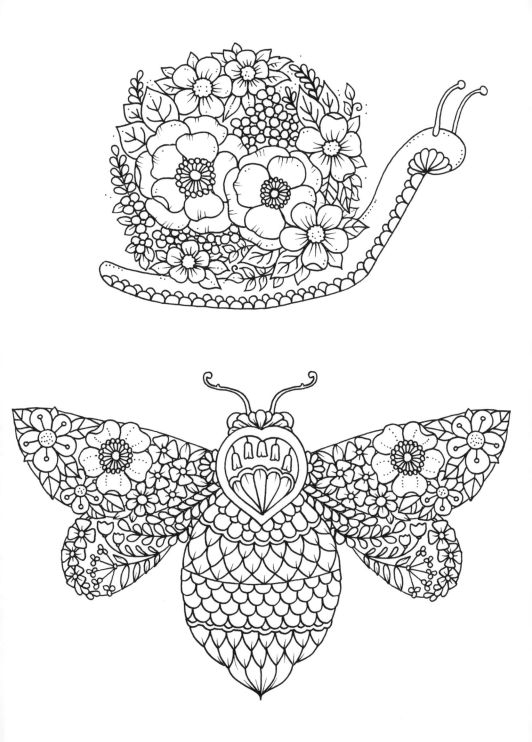

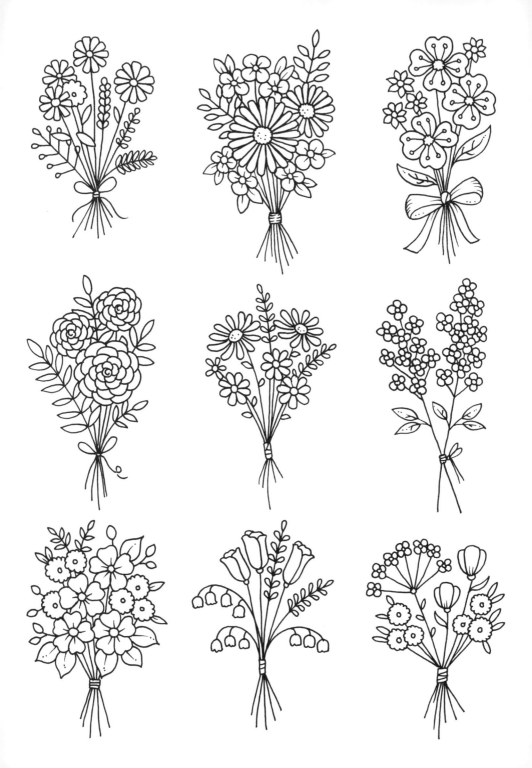

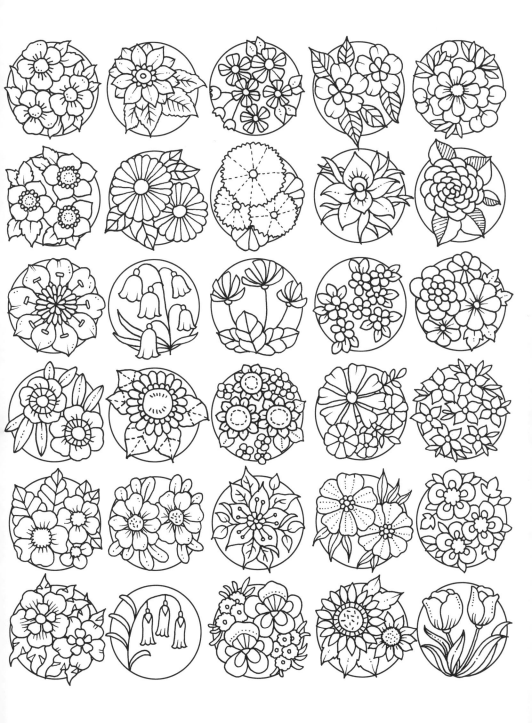

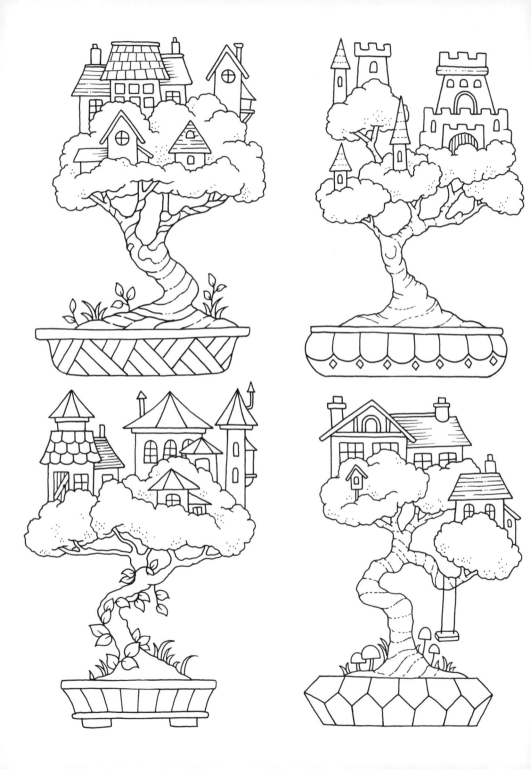

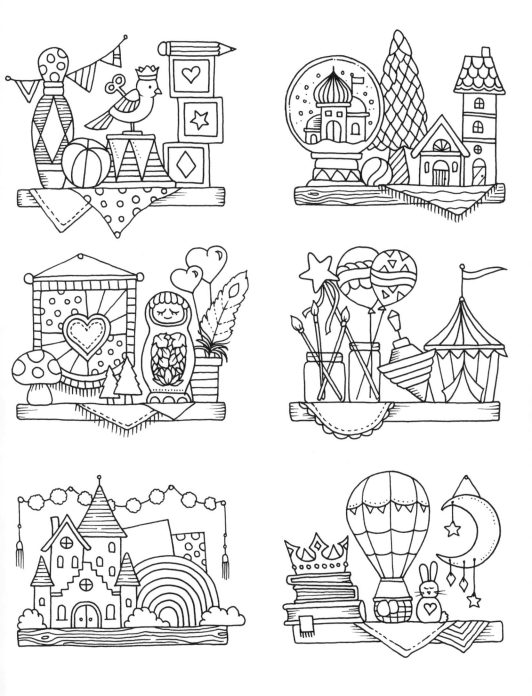

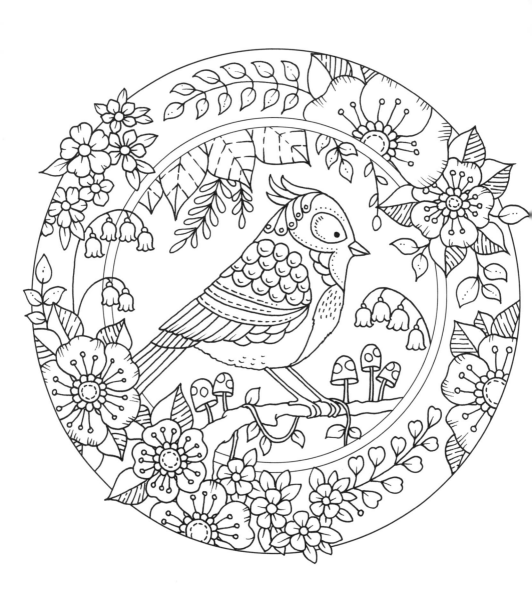

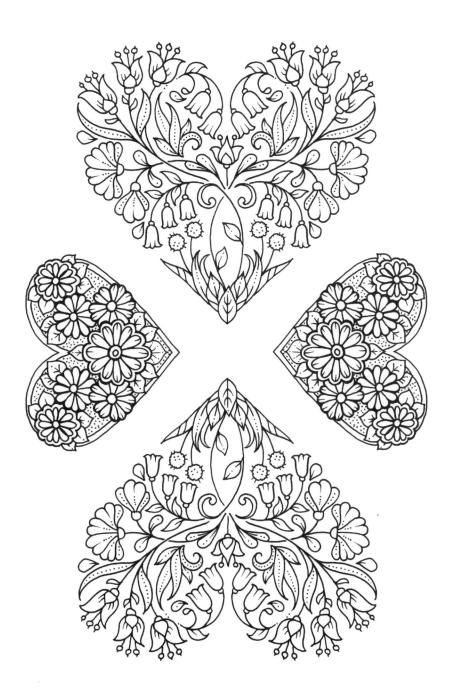

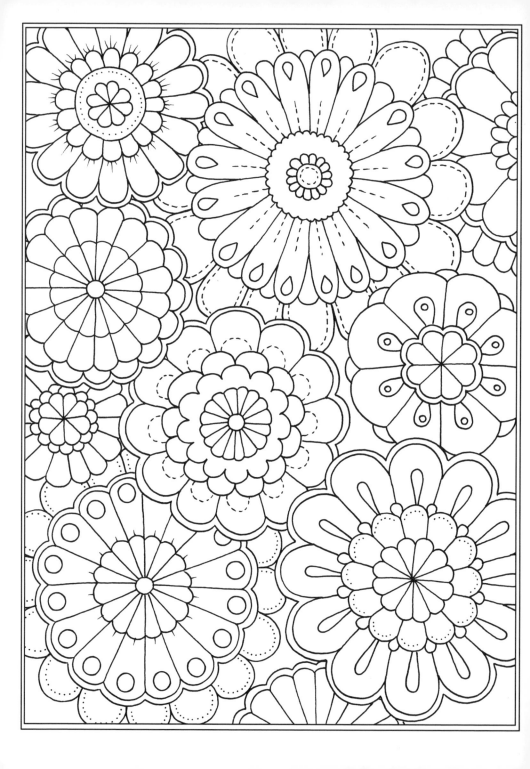

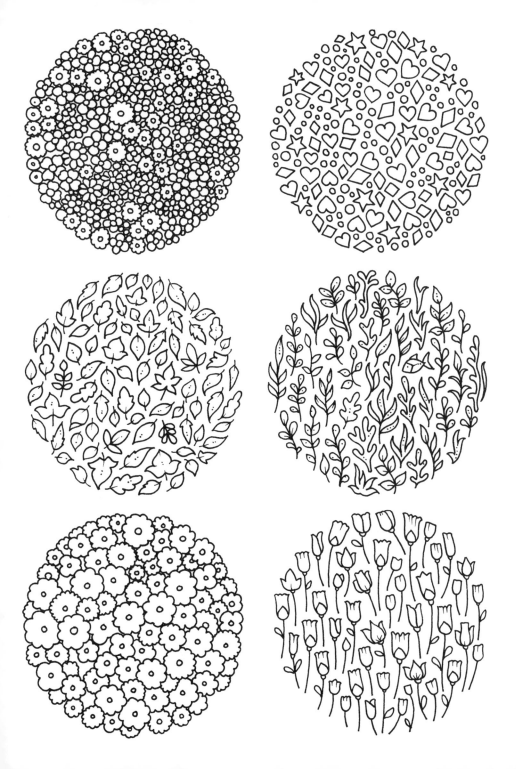

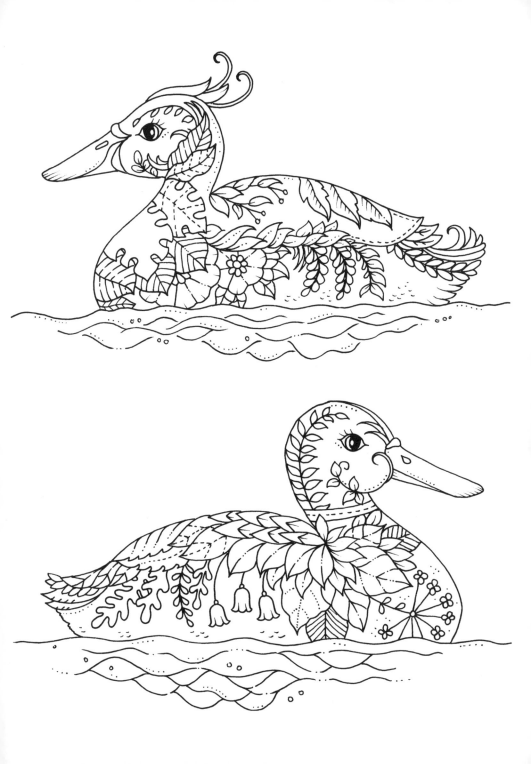

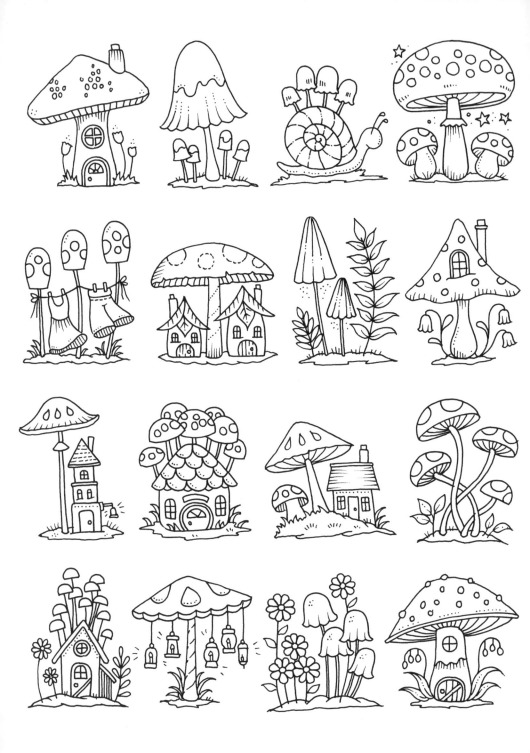

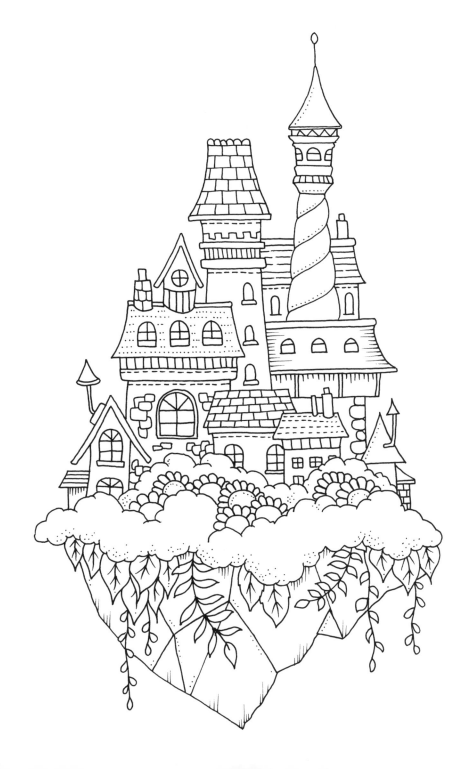

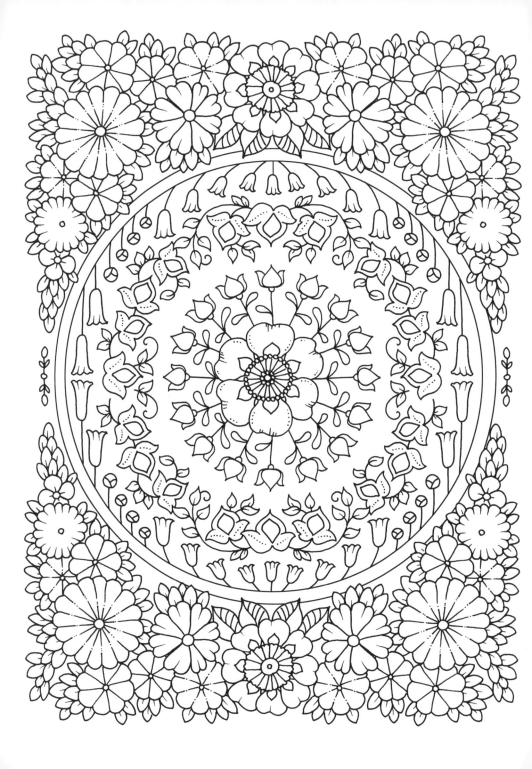

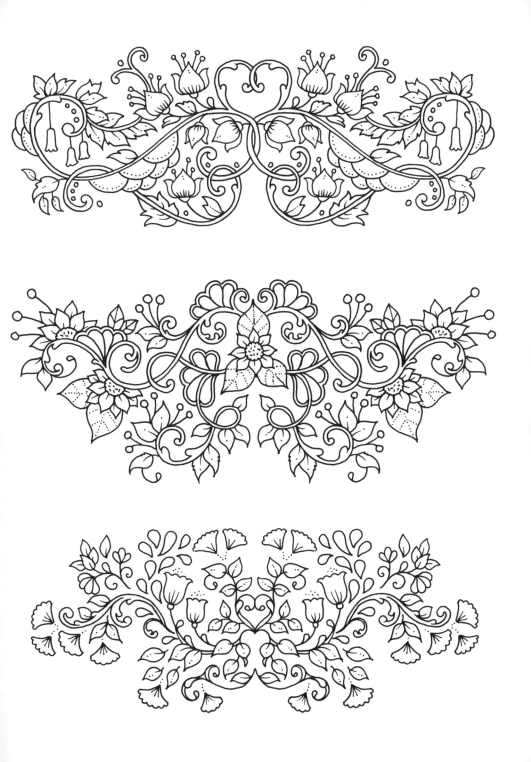

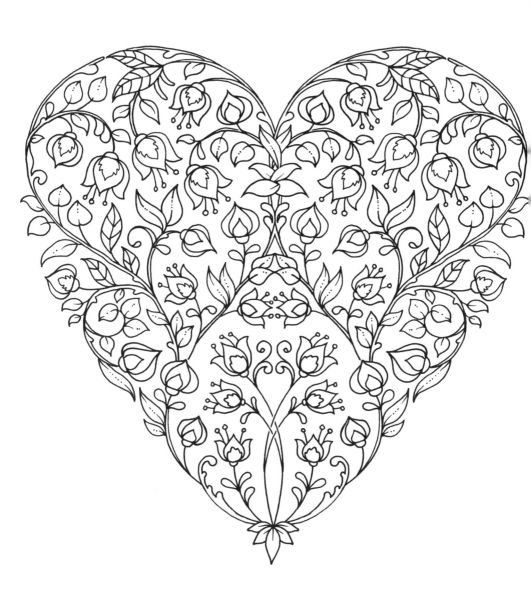

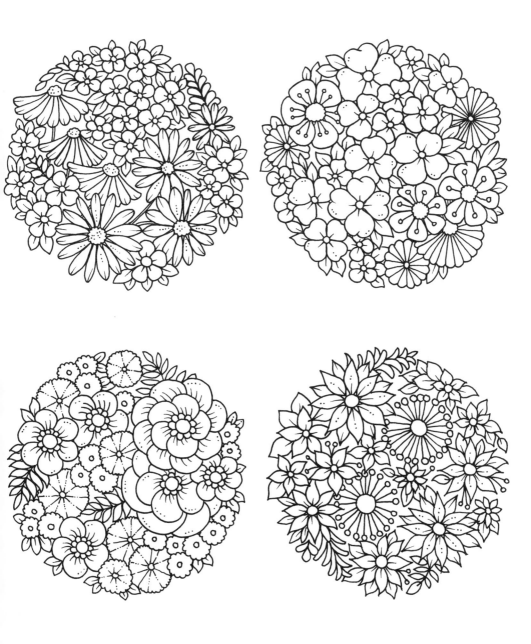

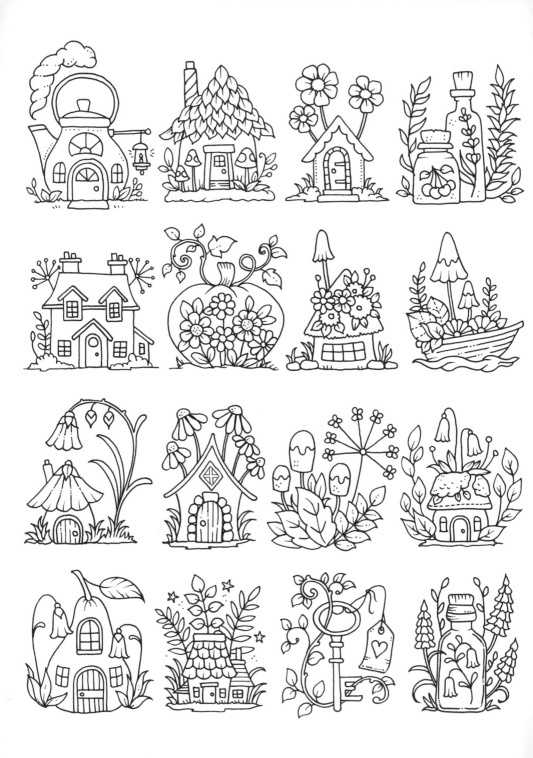

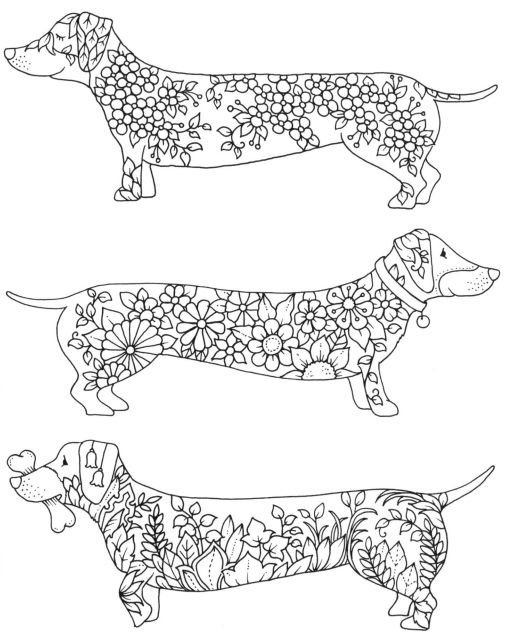

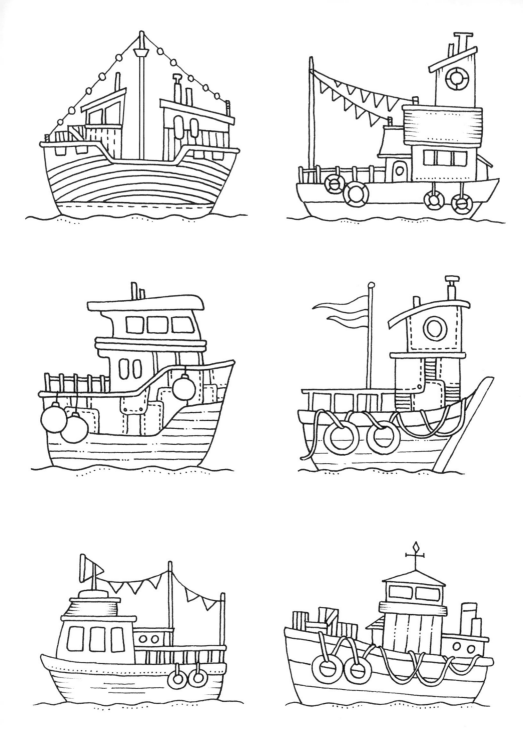

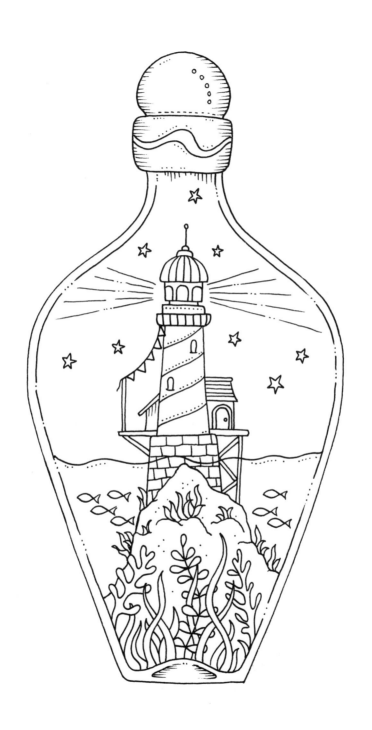

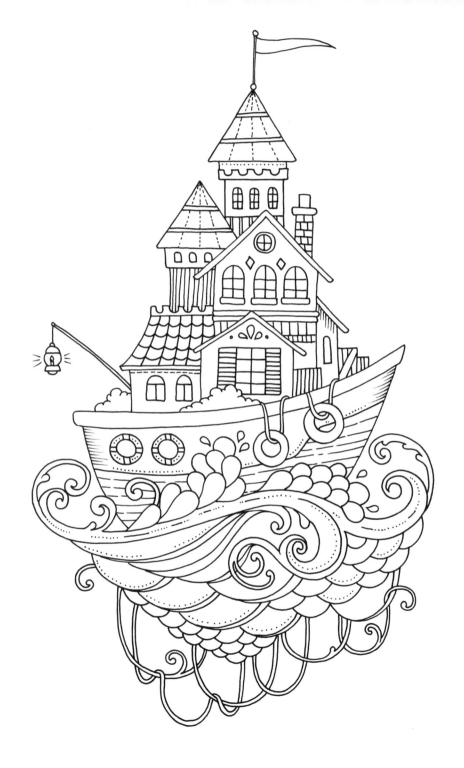

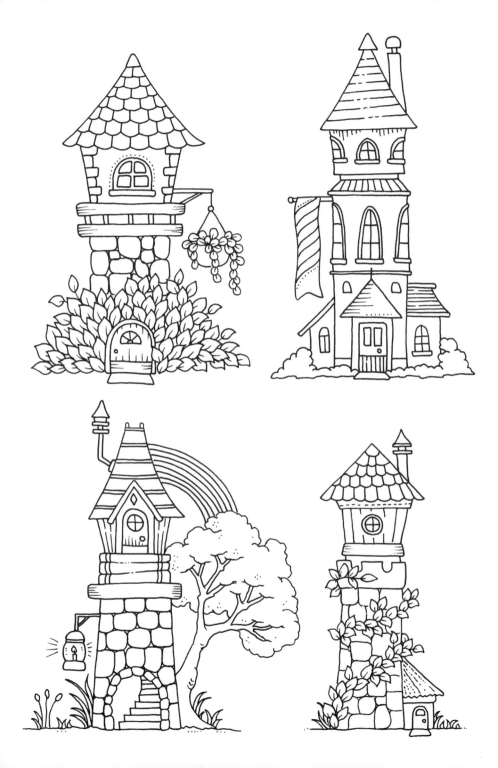

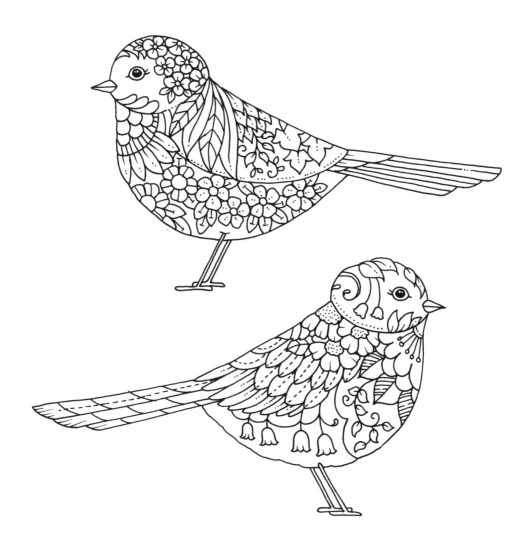

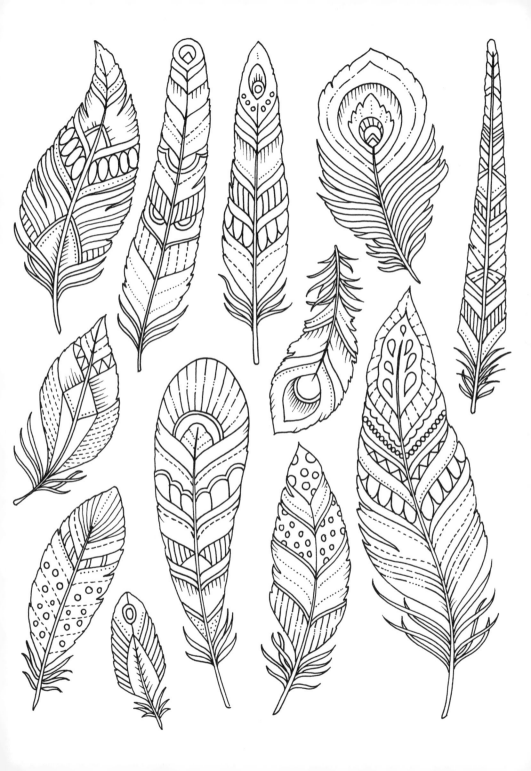

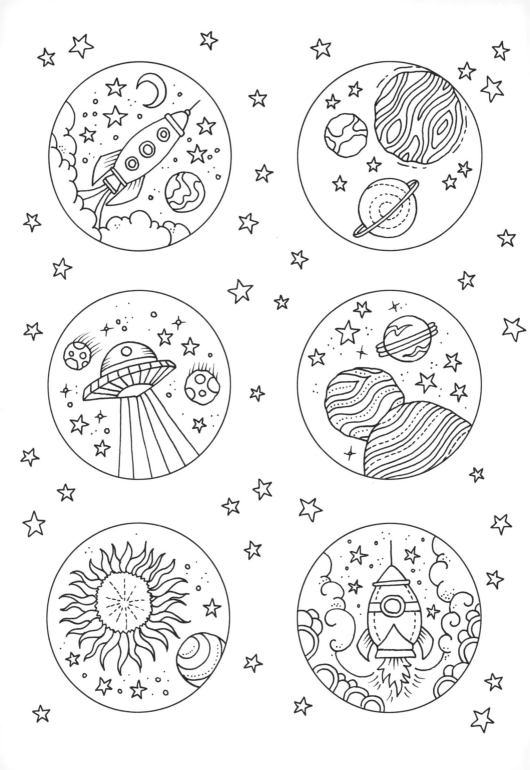

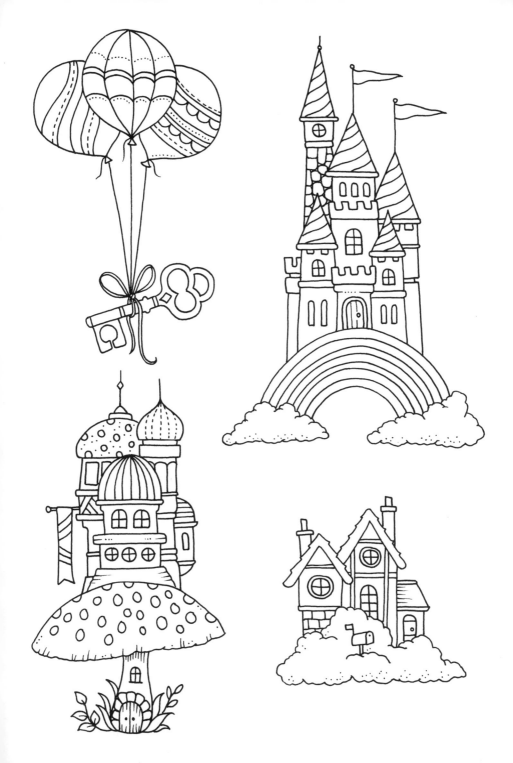

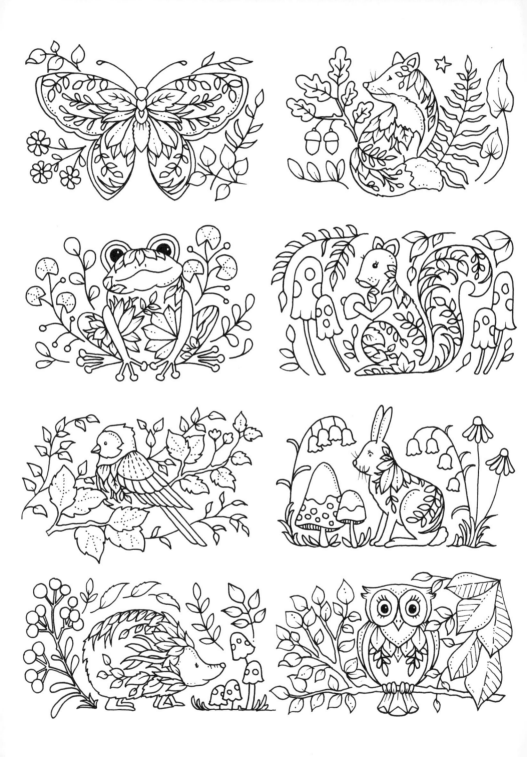

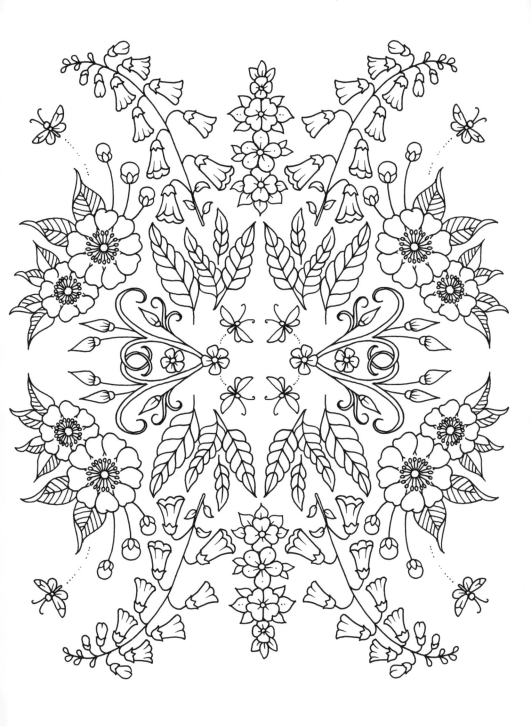

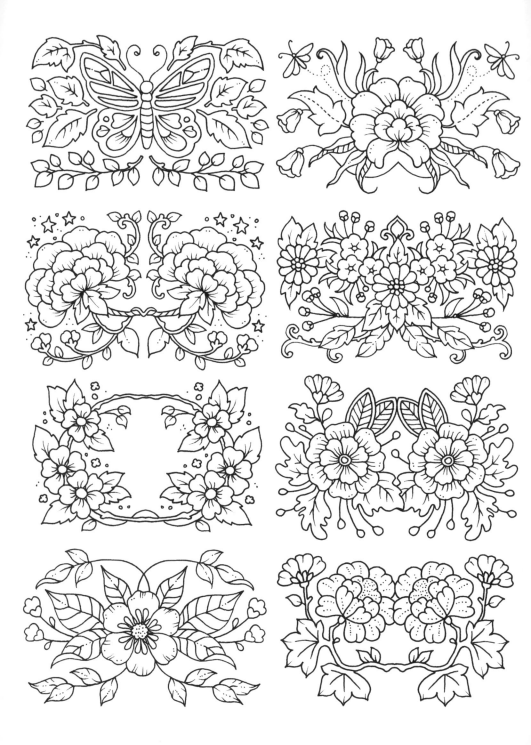

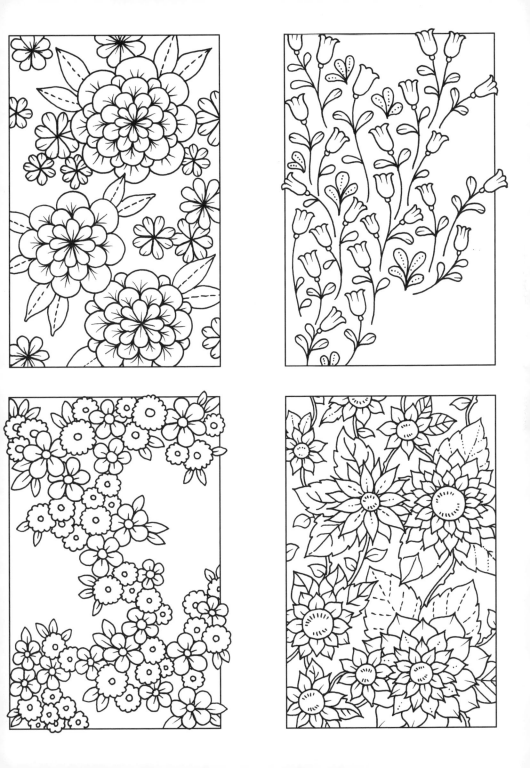

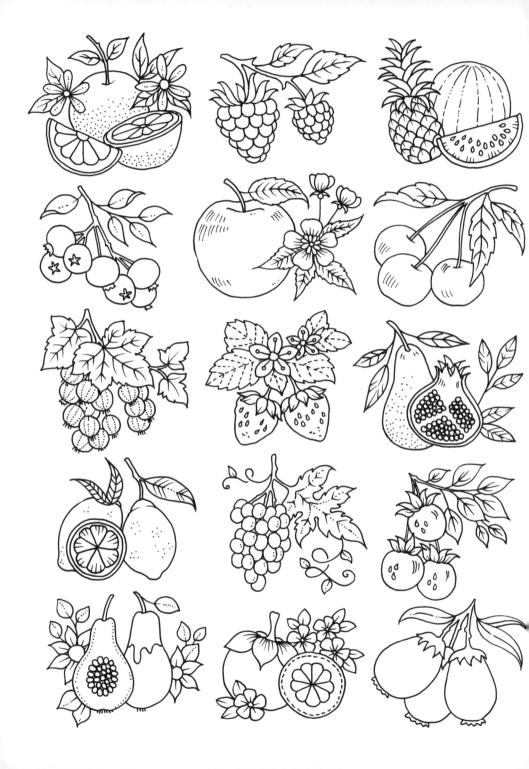

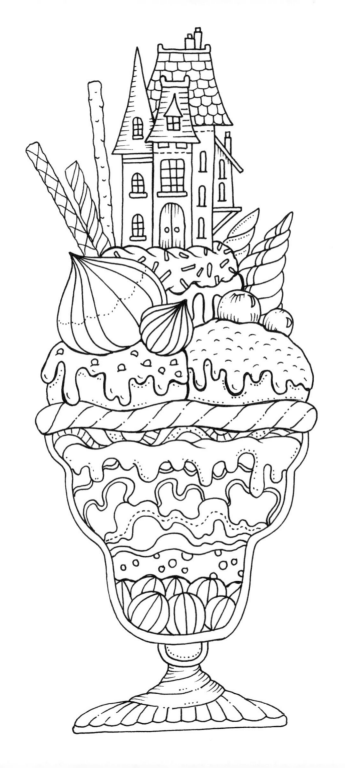

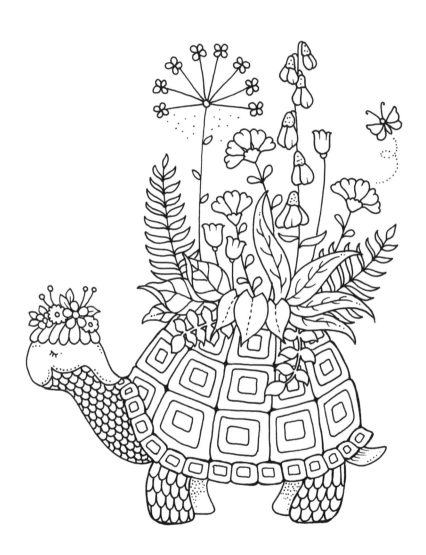

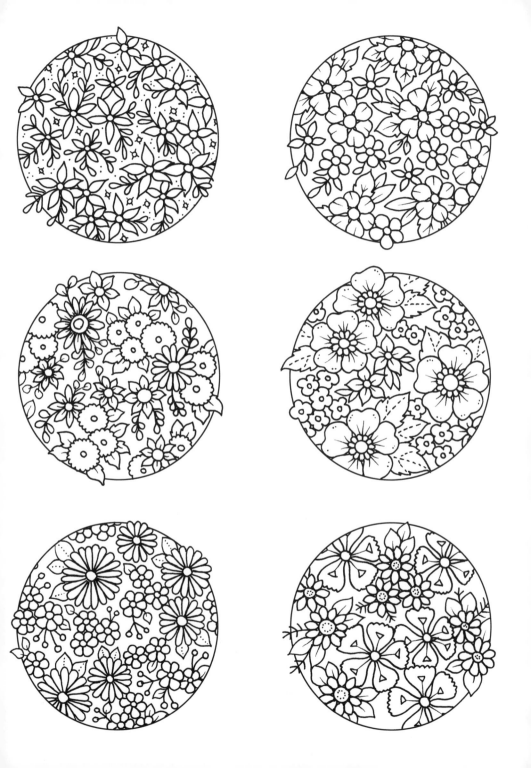

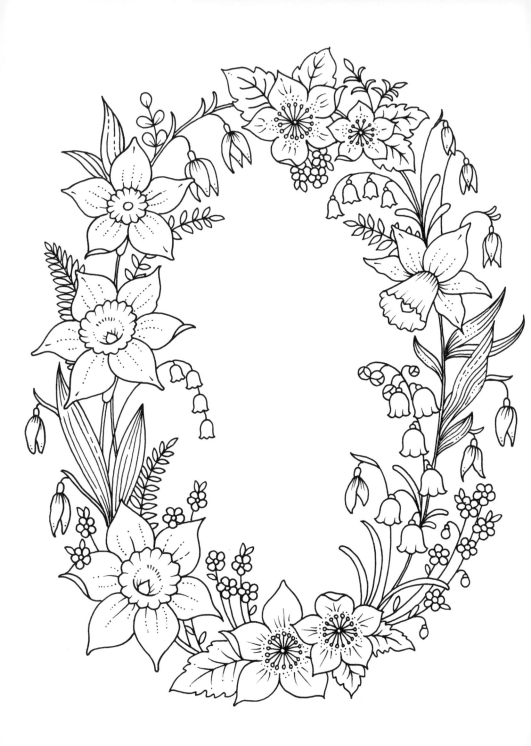

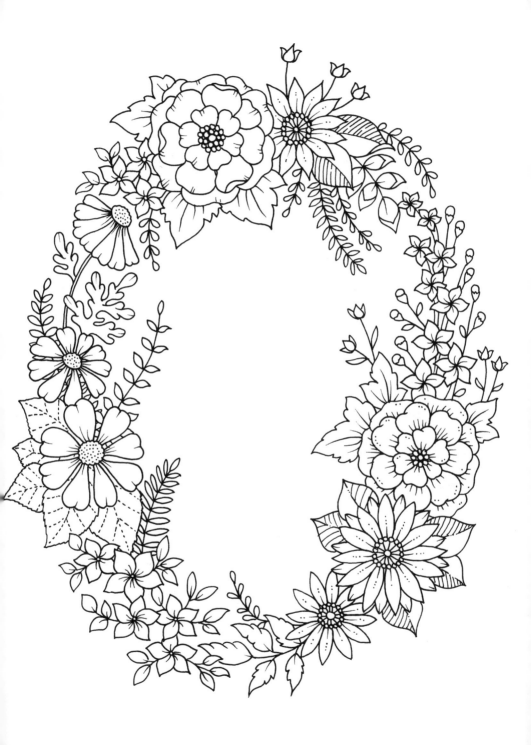

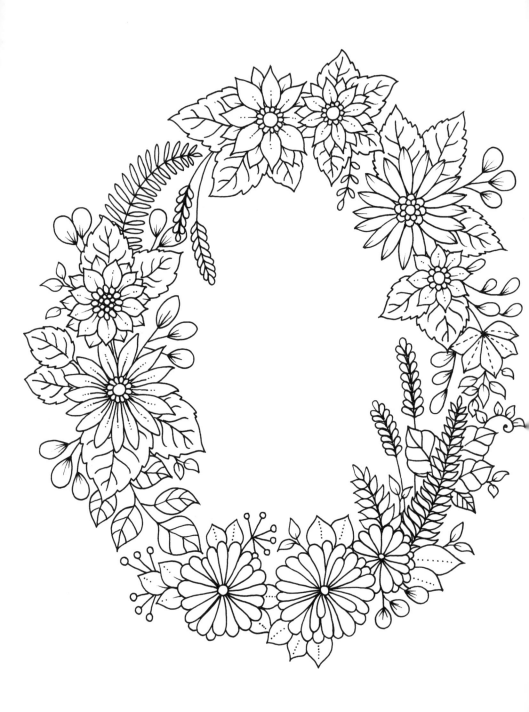

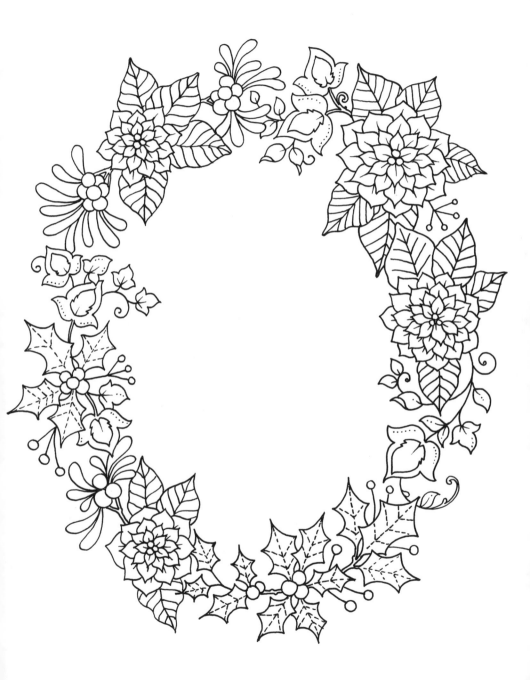

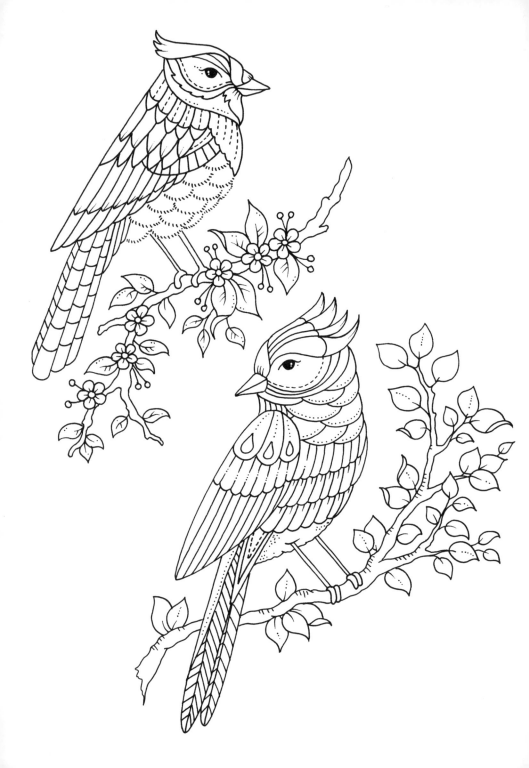

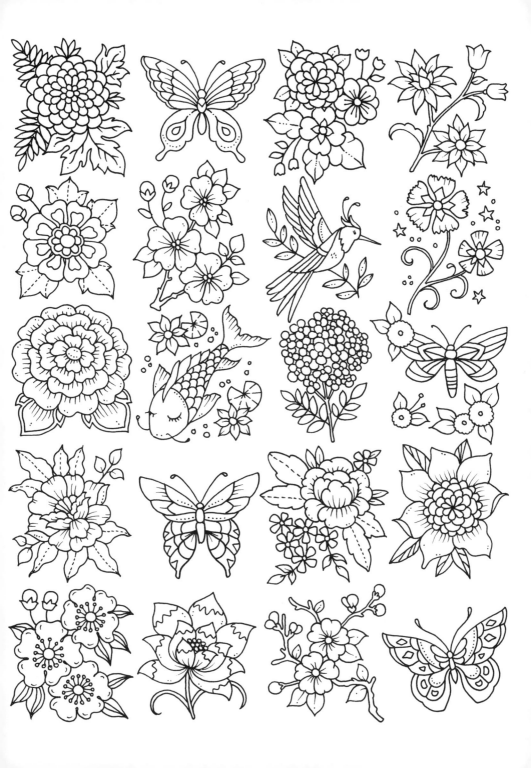

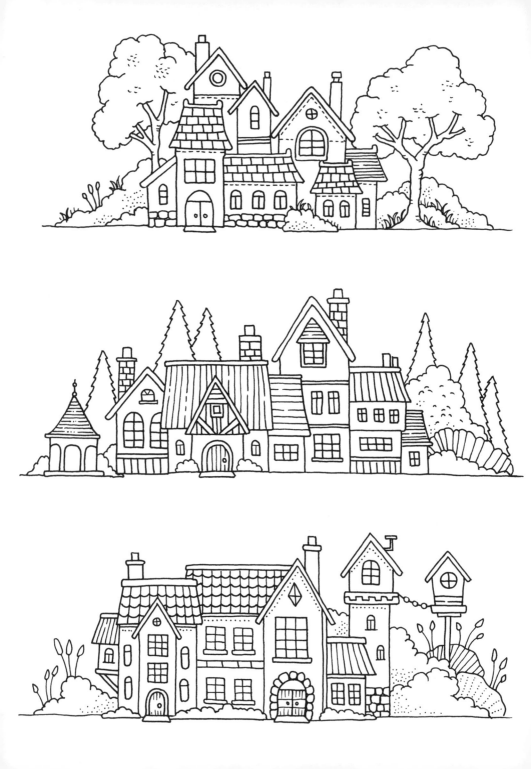

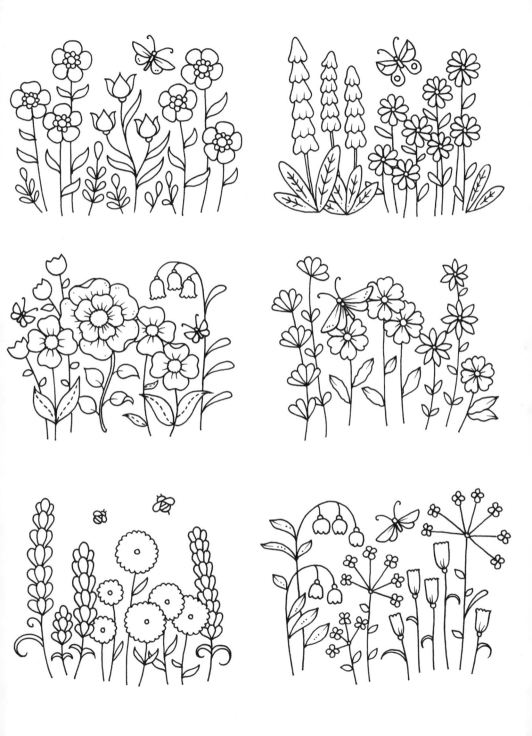

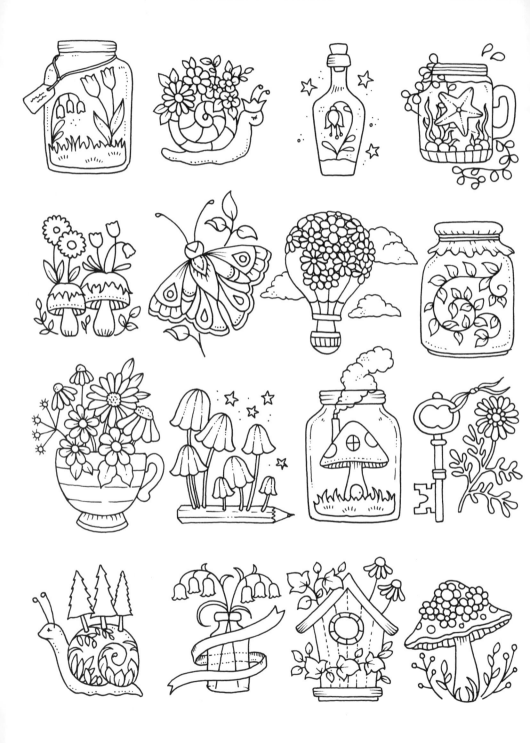

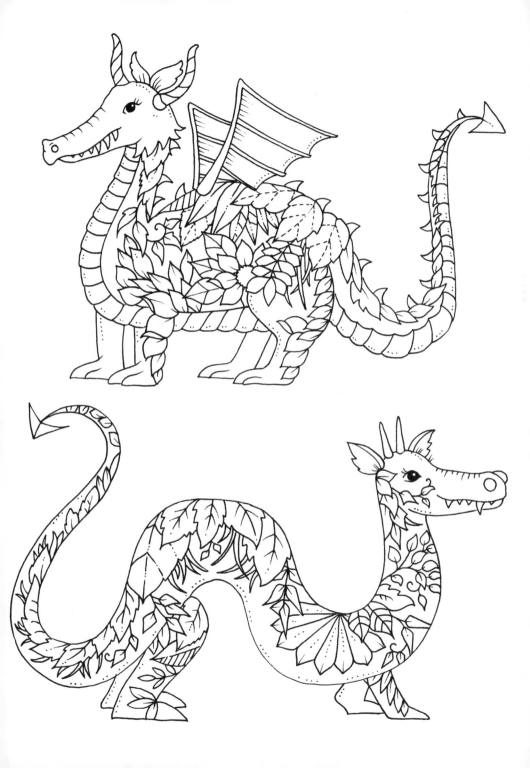

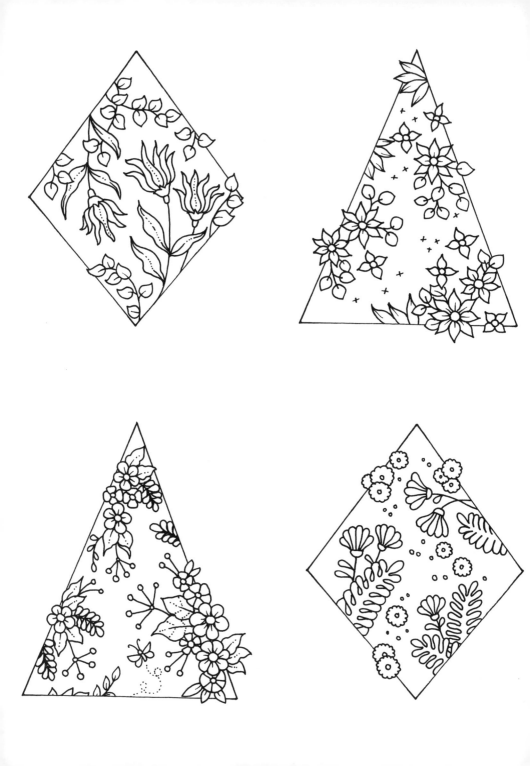

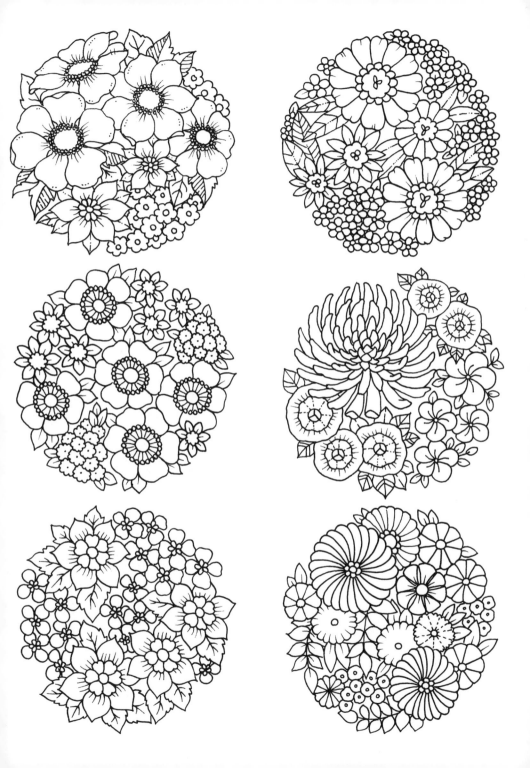

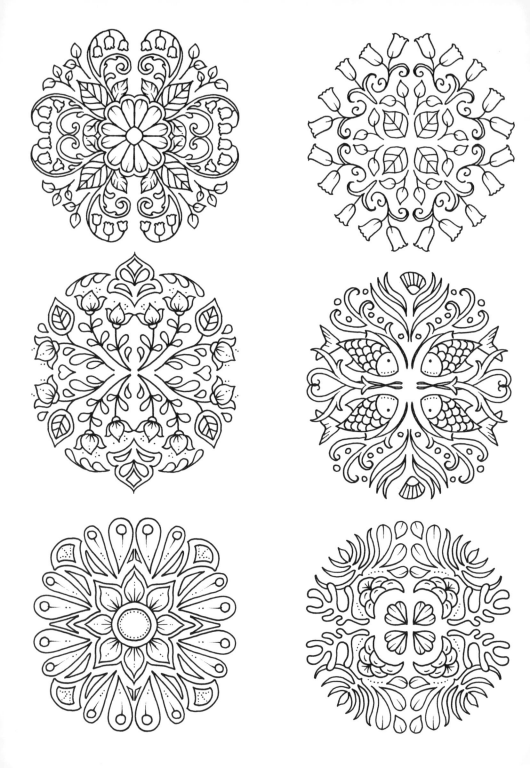

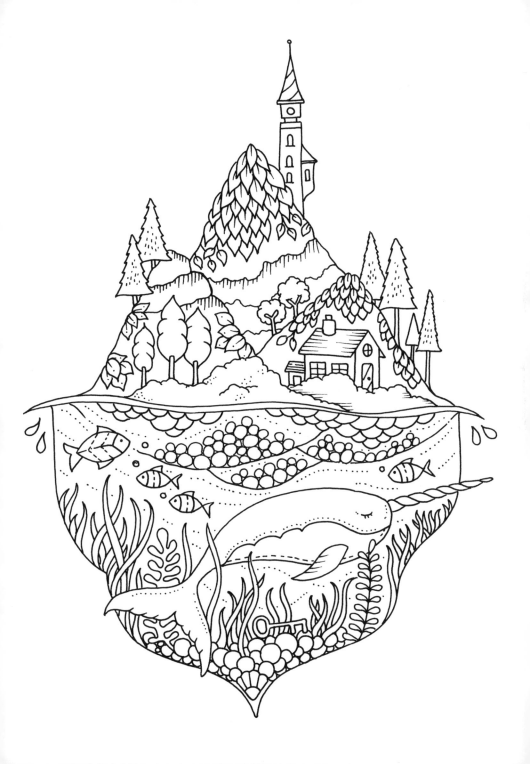

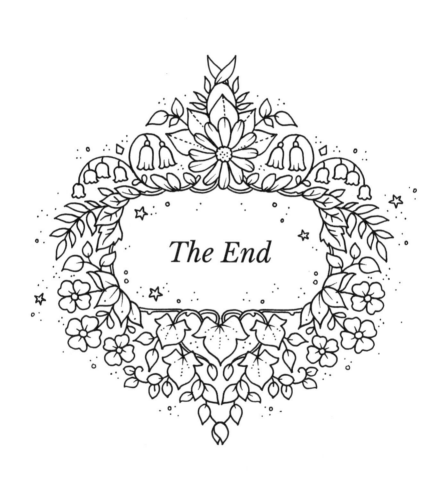

The End

Color Palette Test Page

Color Palette Test Page